LEGENDARY
BEASTS OF BRITAIN

Julia Cresswell

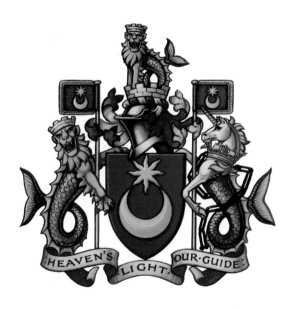

SHIRE PUBLICATIONS

Published in Great Britain in 2013 by Shire Publications Ltd, Midland House, West Way, Botley, Oxford OX2 0PH, United Kingdom.

43-01 21st Street, Suite 220B, Long Island City, NY 11101, USA.

E-mail: shire@shirebooks.co.uk www.shirebooks.co.uk

A CIP catalogue record for this book is available from the British Library.

Shire Library no. 710. ISBN-13: 978 0 74781 204 3

Julia Cresswell has asserted her right under the Copyright, Designs and Patents Act, 1988, to be identified as the author of this book.

Designed by Tony Truscott Designs, Sussex, UK and typeset in Perpetua and Gill Sans.

Printed in China through Worldprint Ltd.

13 14 15 16 17 10 9 8 7 6 5 4 3 2 1

COVER IMAGE

A fifteenth-century Italian depiction of a unicorn, from the Borso d'Este Bible, Vol. II, 1455–61. Ideas about beasts were shared all across medieval Europe. (Biblioteca Estense Universitaria, Modena, Italy / The Bridgeman Art Library.)

TITLE PAGE IMAGE

The arms of Portsmouth, Hampshire; the sea lions and sea unicorn celebrate the city's seafaring traditions.

CONTENTS PAGE IMAGE

A dragon from Edward Topsell's *The History of Four-Footed Beasts and Serpents* (1658).

ACKNOWLEDGEMENTS

The author expresses her thanks to Dominic Strange, and his marvellous website www.misericords.co.uk, for permission to use so many of his pictures; to Peter Maddocks for generously sending me Clever Ness; to Richard Brown for stimulating discussions of the material and information; to Alexander Cresswell for research and insights; to Philip Cresswell for photographs and technical support; to Nick Wright, Russell Butcher and the team at Shire; and to the following for their kind and generous permission to use their material: Ian Chadwick; Dartmoor Border Morris; John Doran; Terje Hartberg; Molly Harwood; Helix; David Hemming; Ulli Joerres; Tom Lee; Donny McIntyre; Brian Mossemenear; Sarah Pellegrini; Robbie Phelan; Adrian Pink; Elly Reynolds; Dominic Strange; Jim Thomson; Gordon Tour; James Wallis; and Robert Young.

I would also like to thank the people who have allowed me to use illustrations, which are acknowledged as follows:

The British Library Board © All Rights Reserved, pages 8, 13, 30 (middle right) 36 (top), 40 (bottom), 43 (bottom), 44 (bottom), 45 (top); Ian Chadwick, page 6; Philip and Julia Cresswell, pages 16 (top), 17 (top), 20 (right and bottom), 30 (bottom) 35 (bottom), 40 (top right), 43 (top); Dartmoor Border Morris, page 25; John Doran, page 11 (top); Getty Images, page 34; Terje Hartberg, page 44 (top right); Molly Harwood, page 23; David Hemming, page 32 (bottom); HSBC Archives, page 42 (bottom); Tom Lee, page 24 (middle); Peter Maddocks, page 35 (top); Mary Evans Picture Library, pages 19 and 28; Donny McIntyre, page 37 (middle); Brian Mossemenear, page 40 (top left); Sarah Pellegrini, page 12; Robbie Phelan, page 24 (top); Adrian Pink, page 17 (bottom); Portsmouth City Council, page 1; Elly Reynolds, page 26; Dominic Strange, pages 7, 14 (bottom), 15, 16 (bottom), 18, 22 (top), 30 (top and middle left), 31 (top and bottom), 41 (top), 42 (top right and left), 63 (top left); Jim Thomson, page 24 (bottom); James Wallace, page 4; Courtesy of the Waterside Theatre, Aylesbury, page 22 (bottom).

Shire Publications is supporting the Woodland Trust, the UK's leading woodland conservation charity, by funding the dedication of trees.

CONTENTS

INTRODUCTION 4

DRAGONS, WYVERNS AND WORMS 8

BIG CATS AND BLACK DOGS 21

MERMAIDS, SELKIES AND FINN-FOLK 28

NESSIE AND HER KIN 34

GRIFFINS, UNICORNS AND YALES 38

FURTHER READING 46

INDEX 48

THE
Flying Serpent,
OR
Strange News out of
E S S E X

BEING

A true Relation of a Monſtrous Serpent which hath divers times been ſeen at a Pariſh called *Henham-on-the-Mount* within four miles of *Saffron Walden*.

Showing the length, proportion, and bigneſs of the Serpent, the place where it commonly lurks and what means hath been uſed to kill it.

Alſo a diſcourſe of other Serpents and particularly of a Cockatrice killed at *Saffron Walden*.

The truth of thi Relation of the Serpent is atteſted.

{ *Richard Jackſon* - - Church-Warden.
{ *Thomas Preſland* - - Conſtable.
{ *John Knight* - - - - Overſeer for the Poor.

By { *Barnaby Thurgood,*
{ *Samuel Garret,*
{ *Richard Seely,* } Houſeholders.
{ *William Green,*

WITH ALLOWANCE.

LONDON, Printed and Sold by *Peter Lillicrap* in *Clerkenwell-Close* * * * * * [1669]

SAFFRON WALDEN:
Reproduced in fac-ſimile by W. MASLAND.
With Introduction by ROBT. MILLER CHRISTY.
1885.
Price Six-pence.

INTRODUCTION

THE MYTHICAL ANIMALS we are most familiar with are those that come from Greece and Rome. The British legends belong only partly to this tradition, for underlying both the classical tradition and the British is a set of ideas that cover the whole of Europe, and very often even further afield. The same basic stories, often called 'international popular tales', are found spread through both time and geographical space. Thus most cultures have some sort of dragon and tales about its slaying, and also stories about humanoid water-beings such as mermaids. These stories often share broad features with each other, but at the same time each culture takes these stories and makes them its own, making changes that fit in with the local culture, and often matching them to local people and landscapes. Thus of the three countries covered in this book, England, Wales and Scotland, each gives its own flavour to the legends.

Britain has few animal stories of romance and chivalry. Instead, there is a marked tendency among the British to make the hero of the legend an ordinary man, often a mere peasant, who rises to the occasion by using his innate cunning or common sense. There may be strong elements of humour or even of the anti-heroic. While these elements can be found in the stories of other countries, they are particularly marked among the British. But this tendency matches the national self-image, and so may reflect a bias on the part of the collectors or publishers of such stories. Another trend is the affection the British show for the fierce creatures of legend, turning them from monsters into objects of amused affection, even literally into cuddly toys in the case of the Loch Ness Monster.

The written sources of the material in this book vary from obscure medieval texts to modern newspapers. It is tempting to divide them into the literary and the popular, but this does not really work. Even the most literary of classical myths had their basis in popular folklore, and literary texts have been shown to have worked their way into folklore and influenced the form that the stories take. Some of what we would now call British folklore was recorded as genuine history by earlier antiquaries, but the bulk was collected

Opposite:
Belief in mythical animals lasted long after the end of the Middle Ages, as can be seen from this nineteenth-century facsimile of a 1669 pamphlet.

5

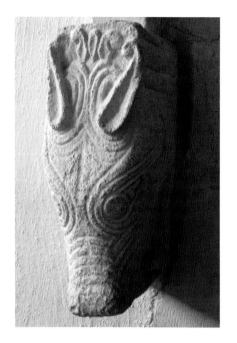

This Anglo-Saxon animal-head carving in St Mary's church at Deerhurst, Gloucestershire, is thought to be the inspiration for the local dragon legend.

by enthusiasts from the nineteenth century onwards. Of particular note as source material is the work of the Folklore Society, which is still actively collecting today.

Among the most important of the early, more literary texts are the bestiaries, various versions of a text originally put together in the second or third century AD (the original is lost), and expanded over the next few centuries. These works describe the natural world as a reflection of what was believed to be God's design. They contain descriptions and stories both of real animals and of creatures that we would now consider mythical but were then thought to be real, and about their imagined behaviour and symbolism. Often beautifully illustrated, the bestiaries were enormously popular and influential, and remain so to this day. They are the source of much that we think we know about unicorns, and of stories that are still current, such as the idea that a lion will not attack a person who lies still. The bestiaries influenced the ideas of naturalists into modern times, as well as legends about beasts, and were a major source for heraldic animals, many of which still feature in everyday life today.

Another important source of stories is the carved images that were so important in the largely non-literate society of the past. As we shall see, these depictions could be the inspiration behind some of the stories we shall meet. For instance, an Anglo-Saxon carving of an animal head in the church at Deerhust, Gloucestershire, is generally accepted as the inspiration behind the story of how a man typically described as a 'mere labourer', with the mundane name of John Smith, joined the landed class as a reward for killing a dragon, not by chivalric derring-do, but by the practical expedient of satiating it with milk (a favourite drink of British dragons), and waiting until it fell asleep with its scales all ruffled up so that he could use his axe to decapitate it. Other such stories will be found in the next chapter.

Many of the most interesting examples of such medieval carved decoration are found on the misericords in churches. In those days the monastic services were very long and afforded only short periods when it was permitted to sit on the fold-down wooden seats. This was hard on elderly monks, so they were allowed to perch on the edge of the upturned seat. To enable this, a ledge, the misericord, was left in the thickness of the seat. It was carved out of the solid wood for strength, but to reduce

the weight much of the wood lower down was cut away. This provided an opportunity for much lively carving, with about a quarter of the surviving figures being of animals. Much of this carving had little or no apparent connection with religion, although this is largely because we are no longer attuned to the symbolism and visual clues that were so important in a mainly illiterate world, and we do not expect sins to be shown in church as often as virtues. Sometimes these carvings remind us that we have lost legends, as in the case of an unexplained misericord in Bristol Cathedral that portrays a naked man apparently fighting giant rats. Unlike much stone carving, which is often eroded, misericords were well protected in the choir stalls, and provide an excellent source of good illustrations of mythical beasts.

Many misericord animals are hybrids, combining body parts from a number of different sources. These creations were much loved by medieval artists and are common in carvings and manuscripts. Similar hybrid figures are found in later heraldry. However, they have no stories associated with them, so do not concern us in this book, which focuses on narrative. While we tend to think of these stories as medieval, many of them, at least in their present form, are later, with stories being created in the nineteenth and even twentieth centuries.

Hybrid creatures from a fifteenth-century misericord, Lavenham church, Suffolk. Note the structure of the misericord: a hinged seat, with ledge to perch on, built into a choir stall.

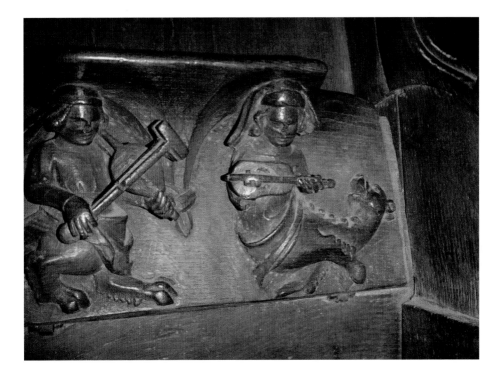

sup te: fozd suas ab cuitate alienus a pie ex tilio ex ipm ico. ex ciato te intuuit
.i. diabolus. Nam si tu habeas spm scm. no potest t appropinquare diato Atten
te ql homo ex pmane in fide catholica. ibiq; habita. ibi pseuera. in una eca
catholica. Caue qntu potes ne ex domu fozis inuenias. ex comphendat te
ille ciato serpens antiquus. ex deuozet te sic iudam ql mox ur gnit a dno fozis
ex filij aplis. statim a demone deuozat est ex pijt.

Anguis nomen comune est serpentium. Ab augo angis dictum.

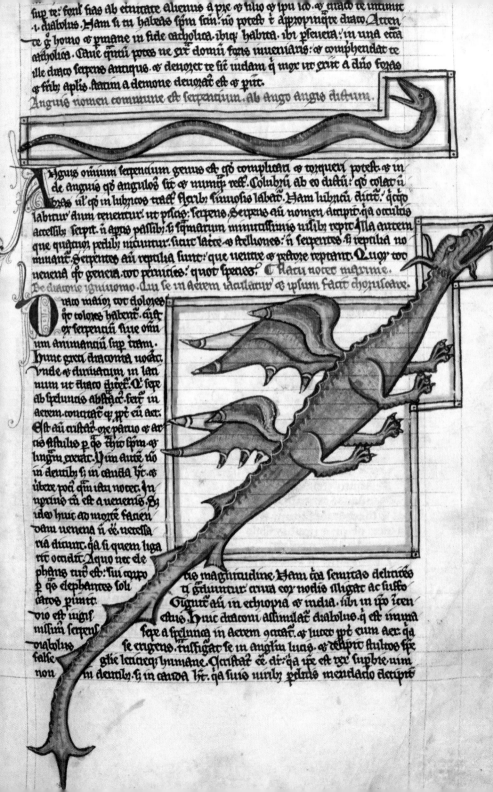

Anguis omniu serpentium genus est qd complicari ex torqueri potest. ex in
de anguis qd angulos sit ex nunql recti. Colubru ab eo dictu qd coler u
bzas ul qd in lubricos tractu fgerit. sinuosis labat. Nam lubricu dicitur. qcqd
labitur dum tenentur. ut pisces. serpens. Serpens au nomen accipit qa occultis
accessibz serpit. n apris passibz; si squarum minutissimis nisibz reptit. Illa autem
que quatuor pedibz nituntur. sicut lacte ex stelliones. n serpentes. si reptilia no
minant. Serpentes au reptilia sunt. que uentre ex pectore reptant. Quoq; uo
uenena eo genera. tot pmicies. quot species. Naturu notet maxime.

De diacone igniuomo. Cui se in aerem iactauit. ex ipsum facit chorusco.

Diaco maior. tot dolores
hijc colores habent. cist.
ex serpentiu siue omn
iu animantiu sup tram.
Hunc greci draconta uocat.
Vnde ex diriuatum in lati
nuum ut diaco dicitur. Qi sepe
ab spelunus abstract. fertur in
aerem concitatq; ppt eu aer.
Est au ciatus ex pauo ex ari
ns fistulis p qo thir spm ex
lingu exerat. Viim aute uo
in dentibz si in cauda ht. ex
uibze pocl qm ictu nocet. In
pcipuo tu est a uenenis. Si
ideo huic ad mozte facien
dam uenena n ee necessa
ria dicunt. qa si quem liga
rit occidit. Aquo nec ele
phans tutus est: sui corpo
p qo elephantes soli
catos pimit.

...nis magnitudine. Nam tota semitas delinies
ql ginuntur. arua cor nodis alligat ac suffo
Gignunt au in ethiopia ex india. ubi in ipo icen
dtus. Hunc draconi assimilat diabolus. ql est imma
sexe a spelunca in aerem gerat. ex lucer ipt cum aer. qa
se erigens. fulsigat se in anglim lucis. ex decipit stultos spe
ghe leticiq; humane. Coristat ee dr. qa ipe est rex superbie. uim
in dentibz si in cauda ht. qa suis uiribz perdita mendacio decipit

vio est igni
missum serpens
diabolus
false
non

DRAGONS, WYVERNS AND WORMS

DESPITE A CLIMATE and geography that might not seem very hospitable to large reptiles, Britain was a hotbed of dragon activity – if we are to believe the sources – with hardly a county without its dragon story. Dragons came in all shapes and sizes, from so large that their teeth formed the Orkney islands, to pesky little things that were put down because they were raiding chicken runs. They are reported from all periods as well, appearing in some of the earliest written records, and still being spotted in the nineteenth and even the twentieth century.

The word 'dragon' comes from the Greek *drakon*, which meant a large snake, often one that guarded a water source or some other special treasures such as the Apples of the Hesperides or the Golden Fleece. This association between water and treasure is also found in later stories about dragons throughout Europe. When the Old Testament was translated into Greek, and subsequently Latin, *drakon* was used to translate two different Hebrew words, one of which could mean a large snake, crocodile or water monster, the other, surprisingly, the word for the desert-dwelling jackal. As was also the case with the unicorn, the appearance of the dragon in the Bible was seen as confirming the creature's existence; the use of the same word as for a crocodile may have helped develop the idea of the dragon as a legged creature, while the reference to the dragon/jackal as a creature dwelling in the wilderness encouraged the idea of the dragon living in a desert caused by its depredations and poison. The Bible also tells us (Numbers 21: 6–8) that when the Children of Israel doubted God during their exodus they were punished by being attacked by 'fiery serpents' (often misquoted as *flying* fiery serpents, which appear in the prophecies of Isaiah; flying snakes have been reported in Egypt and Sinai by other writers since the time of the Greek historian Herodotus in the fifth century BC). These obviously sound dragon-like, but it is now widely accepted that 'fiery' should be translated as 'burning', referring to their painful bites.

We cannot be sure when dragons were first talked of in the British Isles, but they were certainly present with the later Romans, who used a kind

Opposite:
Thirteenth-century
English illumination
of a serpent
and a dragon
(British Library,
Harley 3244).

of military standard called a *draco*. These were poles topped by an open-jawed, bronze dragon head, behind which was attached a fabric tube that would fly out in the wind like a windsock, and would probably have produced a sound as the wind blew through the open mouth. Reconstructions of these standards often use red cloth as it was an established colour for Roman uniforms. This, it has been claimed, is the origin of the Welsh red dragon, said to have been the battle standard of the legendary post-Roman King Arthur (who also inherited from his father the title of Pendragon, or 'chief dragon') and of Cadwaladr, historical king of Gwynedd in the second half of the seventh century. The red dragon was certainly being used as a symbol of the Celtic resistance to the Saxon invasion by the ninth century, when it appears in this role in the texts known as the *Historia Brittonum*, and it is, of course, still to be seen today.

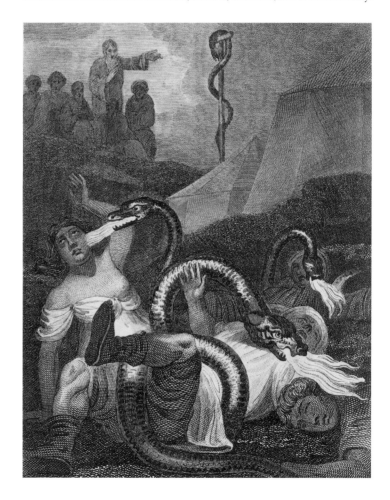

The Children of Israel attacked by fiery serpents: illustration from the 1813 edition of John Brown's *Dictionary of the Holy Bible*, first published in 1769.

The Saxons, whom the Welsh were fighting, were associated with a white dragon, which later became a symbol of the kingdom of Wessex. The invading Saxons brought their dragon lore with them. The only dragon story we have from their literature is that in *Beowulf*, where the elderly hero defeats a treasure-guarding, fire-breathing dragon that is ravaging his land, but it should be noted that the action of *Beowulf* is set entirely outside the British Isles. Elsewhere we read in *The Anglo-Saxon Chronicles* of sightings of fiery dragons in the sky (probably meteors), presaging disaster. But where dragons stand out is in Anglo-Saxon art. Intertwined dragon-like creatures and what are known as 'gripping beasts' abound in art from the earliest examples, and are found in abundance in finds such as those from Sutton Hoo and the Staffordshire Hoard.

However, the word 'dragon' did not enter the English language until the thirteenth century. Before that, the Anglo-Saxons had used the words 'drake' (which came ultimately from *drakon*) or 'worm' (which appears in some antiquarian texts in forms such as 'wyrme'), which could mean any creeping animal, including dragons and snakes. In parts of the country where Norse-speaking Vikings settled, 'worm' appears in place names in the Scandinavian form *orm(e)*, as in the Great Orme, a distinctively shaped headland near Llandudno, Conwy. 'Dragon' appears rarely in place names, although there is a hamlet called Dragon's Green near Horsham in Sussex, which has a local dragon-killing legend to go with it even though its name actually comes from a family with the surname Dragons, who owned the land in the thirteenth century. 'Drake' is more common, appearing in names such as Drakelow in Derbyshire and Dragley Beck in Cumbria, both of which mean 'dragon's hill'.

The ambiguity between snake and dragon (which we find confusing, but obviously did not bother people in the past) is prominent in interpreting place names containing 'worm'. Thus, to the prosaic, London's Wormwood Scrubs prison is built on scrubland where snakes were found, but, to the more romantically inclined, on wasteland created by a dragon. Interpreting these names is further complicated by the fact that both *Orm* and *Wyrma* were also well-established personal names in earlier times. So, the name Worminghall in Buckinghamshire is interpreted as meaning 'nook of land belonging to a man called Wyrma', although the apparent dragon associations were too strong for J. R. R. Tolkien to resist using the name in his comic tale of dragon-slaying, *Farmer Giles of Ham*. The other languages spoken in Britain also keep the snake/dragon ambiguity –

Reconstruction of a Roman *draco* standard, based on the Roman example excavated in Niederbieber, Germany. This standard is used by the Taifali cavalry of the Comitatus late-Roman re-enactment group. The windsock that would stream out behind it is here stored in its mouth.

The Welsh use of a red dragon as its national symbol may go back to Roman times.

Modern
reconstruction
of the Anglo-Saxon
Sutton Hoo
helmet. Note how
the facial features
have been
designed to form
a flying dragon,
with another
dragon coming
to meet it over
the head.

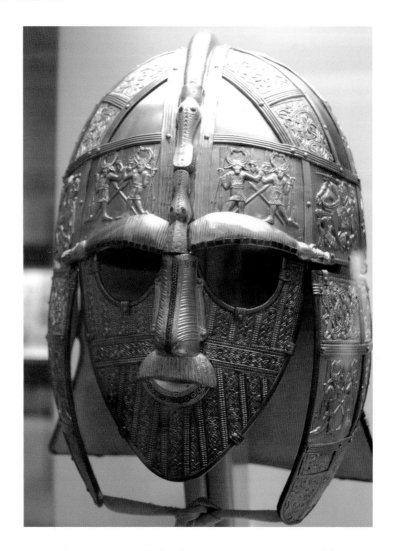

with Welsh using *draig*, 'drake, dragon', in formal writing, although in folklore the creature tends to be described as a *gwyber*, 'viper'. In Scots Gaelic the term is either *dràgon* or *nathair-sgiathach*, literally 'winged adder'. This again emphasises the fact that while the modern world, with our precise animal classifications, makes a clear-cut distinction between snake and dragon, in the past the concept was more flexible.

The wyvern is a dragon with two rather than four legs. Although dragons had long been depicted with four, two or no legs, 'wyvern' was an heraldic term that did not appear until the end of the sixteenth century, although it

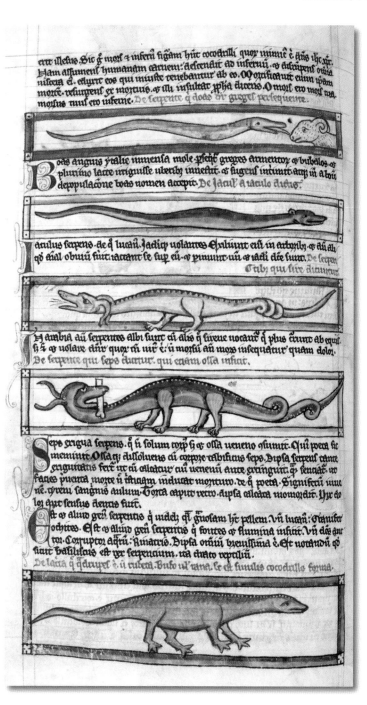

All five of these creatures are described as 'serpents' in this thirteenth-century English illumination (British Library, Harley 3244).

A alternative form to the dragon on page 3, from Edward Topsell's *The History of Four-Footed Beasts and Serpents* (1658), showing that the dragon could still take many forms in the seventeenth century.

St Michael defeating Satan in the form of a dragon: misericord, Gloucester Cathedral.

had appeared in its basic sense of 'viper' (a word to which it is related) two hundred years earlier.

The ambiguity between a crawling snake and a two- or four-legged creature is also present in art. Through the Middle Ages into the early modern period we find illustrations of dragons where the monster is legless, while, conversely, there are also illustrations of snakes that have legs. Pictures of the serpent in the Garden of Eden tempting Eve often show it with legs, because God's pronouncement 'Because thou hast done this, thou art cursed above every beast of the field; upon thy belly shalt thou go' (Genesis 3: 14) can be interpreted as depriving the serpent of the legs it had had until then.

The dragon came into its own with the spread of Christianity, when it came to represent sin, the power of evil, and – influenced by the serpent in the Garden of Eden – the Devil himself, most notably in depictions of St Michael defeating Satan in the form of a dragon, heavily influenced by the Book of Revelation. Thus the dragon came to feature in many saints' legends, most notably for the English in the story of St George and the Dragon.

St George was an early Christian martyr, to whose legend a dragon story was attached. This tells of how the kingdom of Libya was being ravaged by a dragon that guarded the spring that supplied water to the city of Silene. It was placated with sheep, but, when they ran out, it was fed humans.

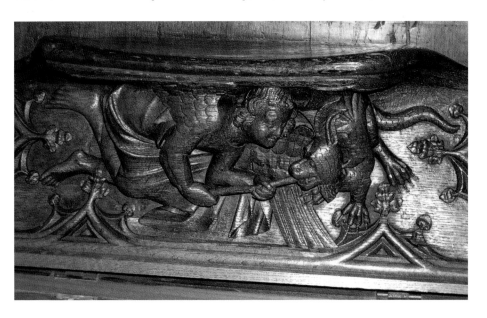

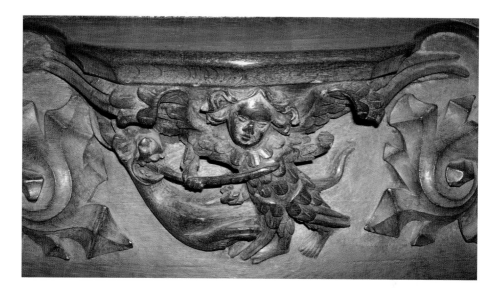

When George arrived, the lot had fallen on the king's daughter. St George fought the dragon and wounded it, and it was then tamed by having the virgin princess's girdle turned into a leash, by which she led the dragon back to the city. Instead of the usual romantic ending of a happy marriage, George asked for no personal reward, but rather demanded that the inhabitants convert to Christianity. If they did not, he would release the dragon; if they did, he would kill it. Fifteen thousand men were said to have been baptised, and the dragon was killed.

St Michael is sometimes shown covered in feathers, making him easily distinguished from St George: fifteenth-century misericord, Carlisle Cathedral, Cumbria.

St George was a popular saint in the Middle East, and a vision of Saints George and Demetrius was seen at the siege of Antioch shortly before it fell to the First Crusade in 1089. This led to Richard I of England putting himself and his army under St George's protection. The return of the Crusaders brought George to greater prominence in England, where he had been known from Anglo-Saxon times. He became the patron saint of soldiers, among many other things, and, after Edward III made him the patron of the Order of the Garter, George gradually ousted the native St Edward the Confessor and St Edmund of East Anglia as patron saint of England. Not surprisingly, a story grew up that he had visited the British Isles. A late version of the legend claimed that he had come to Britain by sea, landing on the west coast after sailing through that part of the Irish Sea that came to be called St George's Channel (a name not recorded before 1578). Even the fight with the dragon was resited to England, most notably to Dragon Hill, in Oxfordshire, which lies just below the great Bronze Age chalk figure known as the Uffington White Horse, interpreted by some

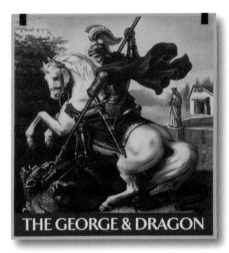

THE GEORGE & DRAGON

The George and Dragon is one of the most popular pub names in England.

St George slaying the dragon: a late-fourteenth-century misericord, St Botolph's church, Boston, Lincolnshire.

as a figure of a dragon. The fight is supposed to have taken place on Dragon Hill's flat top, and the permanent bare patch there caused by the thin soil is said to be where the dragon's blood fell and poisoned the ground for evermore. St George is often shown in art killing the dragon from horseback, but when on foot he can be difficult to distinguish from St Michael. Michael, however, is usually shown with wings.

Despite the popularity of St George, this story has not been very influential on the form of British dragon tales. Saints do indeed occasionally subdue them, the Welsh St Samson, for example, turning a fierce dragon mild by leashing it with his belt, or St Carantoc taming a great serpent by laying his stole on its neck before leading it before an impressed King Arthur; but the majority of dragon tales are secular stories, most often linked to a local geographical feature or explaining a man-made monument. Surprisingly, British dragons are not even strongly associated with guarding treasure. There is the occasional story, such as that of a dragon in the Exe valley that is said to fly at night between the treasures buried under Dolbury Hill and Cadbury Castle, or the treasure-guarding dragon of Wormelow Barrow in Shropshire, but there are no accounts of them being killed for their gold. Nor are the dragons great devourers of maidens, their favourite food being milk. The stories often deal with how a local family acquired its land or coat of arms as a result of getting rid of a predatory

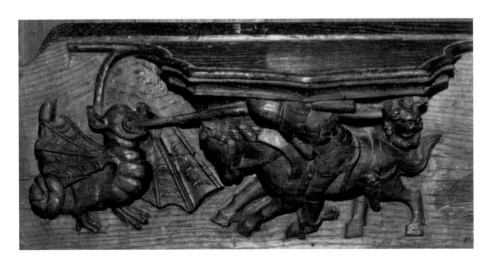

dragon, and the heroes are often local peasants who win the day through trickery. One example of this is the tragicomedy of how Jim Pulk, a farm lad, killed the dragon of Knucker Hole, near Lyminster in Sussex, by feeding him a poisoned pie, only to drop dead himself over a celebratory drink, having wiped his mouth with a hand that still bore traces of the poison.

Perhaps the most romantic of the British dragon tales is that of the Laidly Worm of Spindlestone Heugh, near

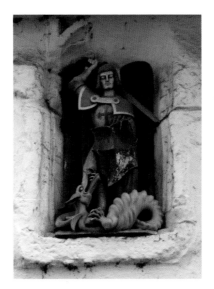

Black-painted wings make St Michael difficult to distinguish from St George: modern statue, St Michael's Street, Oxford.

The view from the Bronze Age Uffington White Horse, Oxfordshire, with Dragon Hill below to the left. The permanent white patch, said to have been caused by dragon venom, can be seen on its flat top.

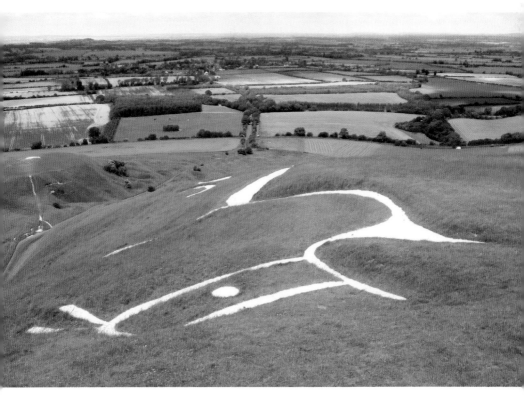

Dragon:
fifteenth-century
misericord,
Norwich
Cathedral,
Norfolk.

Bamburgh Castle in Northumberland, although much of the romance may come from the fact that the story was pieced together from fragments of earlier ballads, and probably heavily rewritten, in the eighteenth century. This is a fairy story that tells how the king's new wife used her skills as an enchantress to play the wicked stepmother and turn his daughter into a hideous dragon, known as the Laidly (loathsome) Worm. The transformed daughter fled to Spindlestone Heugh, a nearby pillar of rock, which she wrapped herself around, and then, following her new nature, began ravaging the countryside. Her brother, Childe Wynd, came to rescue his land from the dragon's depredations, fought and defeated her. As he was about to deliver the killing stroke he noticed the dragon was crying, and stayed his hand. The dragon was able to explain that she was his sister, and the only way for her to escape the enchantment was for him to kiss her hideous face three times. Wynd eventually steeled himself to do this and she was released from the spell. They then returned to Bamburgh, where striking the wicked queen with a rowan twig was enough to turn her into a toad, which is said to lurk still beneath the castle. On Christmas Eve every seven years her lair is accessible, so that any man who has the nerve to go and kiss *her* three times may release her from her enchantment.

Much more typical of the British tales is that of the Lambton Worm from County Durham, which tells how John Lambton, the son of the local lord, wickedly went fishing on the sabbath rather than going to church. He caught a strange creature (perhaps a newt – these were often regarded as embryonic dragons), which he threw into a local well. He then saw the error of his ways and went off to the crusades. When he returned, he found that the creature had grown into a dragon that devoured livestock and could be pacified only with large quantities of milk. Even cutting the dragon in half did no good, for the halves rejoined. So Lambton dressed himself in spiked armour and lured the worm to an island in the river. When it wrapped its coils around him, the spikes cut it to pieces, which the river washed beyond hope of rejoining. In the nineteenth century visitors could still see the trough the dragon drank its milk from, and in the hall a statue of Lambton and a piece of the dragon's hide. A comic version of a similar story is told of More of More Hall, who also wore spiked armour to fight Yorkshire's Wantley Dragon, defeating it only after using his spiked shoe to kick the dragon in its one vulnerable spot, or, as an 1865 version says, 'hit him a kick on the arse'.

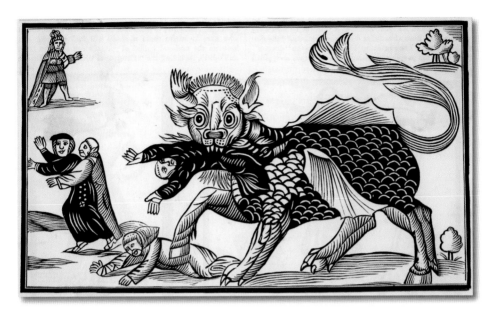

Durham has two families that owe their land to dragon-slaying ancestors. A Pollard of Pollard Hall at Bishop Auckland was rewarded with land by the Bishop of Durham for his exploits and in return had to present a falchion (a type of sword – see illustration on the next page) to each new bishop on his inauguration. This custom was in existence by 1399 and continued until 1828, and has since been revived. Similarly, Sir John Conyers was rewarded with the manor of Sockburn, and he too had to present each new bishop with a falchion. The Conyers falchion in now in Durham Cathedral treasury. The Pollard crest is a falchion; that of Conyers a falchion piercing a dragon.

Dozens more such stories could be cited, but we will return to the two stories mentioned at the beginning of the chapter. The *Mester StoorWorm* from Orkney features a boy called Ashipattle, considered a lazy good-for-nothing. His country was ravaged by a sea dragon so vast that the seven maidens it was fed weekly disappeared with one flick of his tongue. People mocked when Ashipattle said he would kill the StoorWorm, but he got hold of a burning peat and a boat and sailed out to where the worm was sleeping. When the worm yawned, the boat was sucked into its maw. Ashipattle used the peat to set fire to the monster's inside, and, as the fire caught, he and his boat were vomited up again. The worm died slowly, shedding teeth, which became the islands of Orkney, Shetland and the Faroes. Finally the worm curled up and its body became Iceland. The volcanoes on this island show that the fire is still burning.

Wales generated dragon stories into modern times. In 1812 a dragon was spotted in the Vale of Edeyrnion, Denbighshire, and a hunt was arranged

The Dragon of Wantley seizes another victim: broadsheet ballad, c. 1700. By this date strong humour was being used to undermine romance. Wantley is now Wharncliffe, near Sheffield, South Yorkshire.

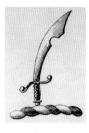

Above: The distinctively shaped falchion sword, used as a crest by the dragon-slaying Pollard family of Pollard Hall.

Right: Late-Victorian ceramic roof finial, Oxford.

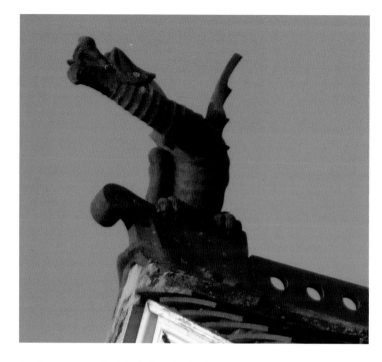

Below: Dragon boot-scraper, early twentieth century.

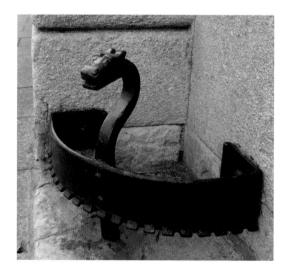

for the creature, which had a long body, short wings, was covered with bright scales and had two glaring eyes. The monster was eventually recognised to be a cock pheasant that had strayed from its normal range. Early in the twentieth century folklorists in Wales collected stories of feathered, bejewelled serpents or dragons that used to live in the Vale of Glamorgan. It was these that were exterminated for raiding chicken runs. The descriptions of their bright feathers bring to mind the pheasant incident. The sources said they themselves had seen the preserved skins of the animals, which had only recently been destroyed.

Dragons have remained a familiar part of our environment and are among the most common features in heraldry and in architectural decoration, being particularly common in churches and Victorian Gothic buildings.

BIG CATS
AND BLACK DOGS

THERE ARE MANY British superstitions about domestic cats – that black cats are either lucky or unlucky, depending on the part of the country; that they are witches' familiars; that they or their blood can be used in various folk cures – but there are probably only two cases where they can be called truly mythical animals. The first is the widely found story that there is a king of the cats, sometimes given a name such as Big Ears, Tom Tildrum or Tom Toldrum. Typically, the story tells of someone who owns a particularly fine cat; one evening a delegation of cats comes to him and tells him to inform his cat that the old king is dead. When he does this, his cat declares 'Now I am king of the cats', leaves, and is never seen again.

The other great fictional cat is Dick Whittington's. This is an international popular tale that has become attached to the real-life Richard Whittington (*c.* 1354–1423), who was not 'thrice Lord Mayor' of London, as in the story, but actually held the post four times. The story of a poor boy who makes his fortune by selling his only possession, a cat, to the ruler of a distant country that is infested by rodents has little else to do with the real Whittington, other than the name of his real-life wife, Alice Fitzwaren. It seems to have become attached to Richard Whittington very quickly, perhaps because the remarkably generous charities the childless Whittington established in his will made him seem a mythic person. When Newgate Prison was rebuilt in 1422 a cat was included in the carving on the gate; the story had been turned into a play by 1605, and Pepys records in his diary seeing it as a puppet show in 1668. It is first recorded as a pantomime in 1815, and it remains a popular choice for that peculiarly British form of Christmas theatre today (see overleaf).

Much more important in British folklore are mythical big cats, which are found in some of the earliest surviving texts. First among them is Palug's Cat (Welsh *Cath Palug* or *Cath Baluc*), which is found in Welsh poetry preserved in manuscripts dating from the thirteenth century, but containing material that could be as early as ninth-century. One poem, *Pa Gur* ('What man?' in Welsh), tells us that Cai (the Sir Kay of Arthurian literature) went hunting lions in Anglesey and there encountered Palug's Cat, which had

A cat playing a fiddle; a play on both the yowling of cats and the use of catgut as strings: fourteenth-century misericord, Wells Cathedral, Somerset.

Though it has strayed a long way from the form of the original story, *Dick Whittington* is still a popular pantomime plot, with several theatres presenting it every Christmas. This picture is from the 2011–12 production at Aylesbury's Waterside Theatre.

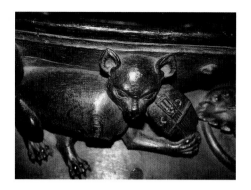

already eaten nine score warriors. Elsewhere, we are told that the magic pig Henwen gave birth to a kitten, which was thrown into the Menai Strait, which separates the north-west of Wales from the island of Anglesey. The kitten must have swum successfully across the strait, for she is said to have been raised by 'the sons ... of Palug ... to their own harm'. In fact, *Palug* comes from a word meaning 'scratch, claw', so the name means something like 'scratching cat'. Its story, the details of which are now hazy, must have been widely known in the past, for not only is the common wild plant silverweed called 'Palug's Cat's paw' (*Palf y Gath Palug*) in Welsh, but a monstrous cat known by names such as Capalu or Chapalu (French *chat*, 'cat', + Palug) occurs in several medieval French and German

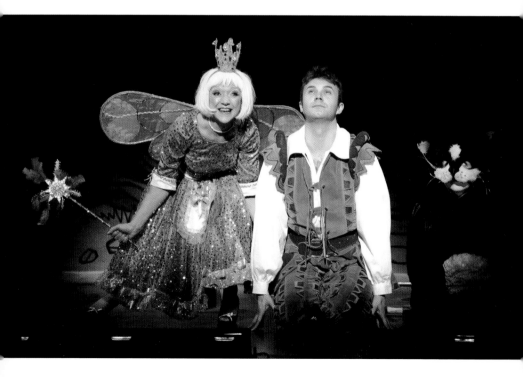

Arthurian romances, even, in one version, being a shape-shifted human who kills Arthur and conquers Britain. The fourteenth-century Scottish chronicler John of Fordham reports a story of how Kay slew a gigantic cat, which would seem to be the same story, and there is a fifteenth-century English manuscript account of how Arthur destroyed wild cats in Cornwall.

Cath Palug's swimming ability and the French shape-shifting have led some to associate it with the *murchata* or giant sea-cats of Irish tradition. These are not just sea-dwellers, but can also be found on land, either emerging from fairy mounds or guarding treasure, and can be bewitched or shape-shifting humans. The similar *cait sith* or fairy cats of Scotland, big as a dog and detectable from the giant footprints they leave behind, must also be related to these mythical cats.

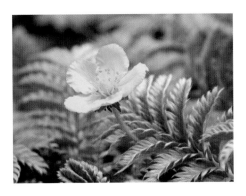

The silkily furred leaves of the silverweed (*Argentina anserina*) give it the Welsh name *Palf y Gath Palug* (Palug's Cat's paw).

But there is another, more literal interpretation that has recently become available. It used to be accepted as a fact that the lynx died out in Britain at least four thousand years ago, but in 2005 some bones from Kinsey Cave in the Yorkshire Dales were carbon-dated, which showed that the lynx was around in the period AD 425–600, exactly the period that Arthurian and other Dark Age heroes are associated with. As it is unlikely that this particular lynx was the last one, who knows how long the creatures lived on in Britain, and what influence they may have had on 'big cat' legends, for the lynx is a hefty animal, growing to 51 inches long and weighing 66 pounds or more. Another archaeological excavation, on the Llyn Peninsula to the south of Anglesey, has found lynx bones with cut marks, showing that a human skinned it for fur, although these bones have yet to be dated.

The modern equivalents of Palug's Cat are the many sightings in Britain of what are known as 'alien big cats'. There is little evidence for any stories circulating about pumas, panthers and other fierce carnivores being seen in Britain before the 1960s, when local reports of big cat sightings were enthusiastically taken up by national newspapers. This is not to say that none of the reports was genuine. The wild cat (*Felis sylvestris*), the size of a very large domestic cat, and easily mistaken for something even larger when seen at a distance, is the only native British cat. However, there can be no doubt that there have been non-native species released into the wild. It is thought that they must have been unwanted pets, and numbers may well have increased after 1976, when it became illegal to keep animals deemed dangerous without a licence and proof of suitable containment. In 1988, for example, a motorist ran over a swamp or jungle cat (*Felis chaus*) in Hampshire, and another specimen of the same species was found dead in Shropshire; in 2001 a lynx

The European lynx was once thought to have died out in Britain in the last ice age, but it is now known to have survived well into historic times, so it may lie behind the stories of Palug's Cat.

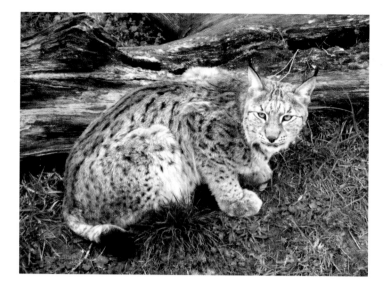

The British wild cat, the only felid native to the United Kingdom, may be the source of some of the stories about big cats.

Bottom: Felicity the puma was caught in 1980 at Cannich, Invernesshire. She lived for a further five years in the local zoo and is now a stuffed exhibit in Inverness Museum.

was caught sitting on a garden fence in Cricklewood, North London. Large black cats seen around Kellas, Morayshire, have turned out to be hybrids between feral cats and the Scottish wild cat. It has been suggested that their ancestors may have been the origin of the *cait sith*. Most famous of all the real alien big cats is Felicity, the Cannich puma. She was caught in a cage

trap in Cannich, Inverness-shire, in 1980, lived for another five years in Kincraig Wildlife Park, and can still be seen as a stuffed exhibit at Inverness Museum. However, Felicity was obviously tame and easily caught, making her an exception.

Typically, stories of legendary big cats develop as newspapers pick up reports of some fierce cat supposedly spotted repeatedly in a given area. Over time the sightings increase, and the animals are given a name such as the Beast of Bodmin, the Beast of Exmoor or the Sheppey Panther. The Cambridgeshire Tiger turned out, in at least one instance, to be a tiger-print car-seat cover, while in May 2011 armed police, a helicopter with a heat-sensitive camera and a zoo team armed with tranquilliser darts were turned out to capture a white tiger spotted near Southampton. When the helicopter downdraft blew it over, it was realised that it was no more than a large stuffed toy. More typical wild-cat scares involve reports of livestock being killed, and a big hunt is organised (in the case of the Beast of Exmoor the military were involved). However, the animal is never captured, unlike Felicity.

The animal that seems to have sparked off this spate of wild-beast sightings was the Surrey Puma, first reported in 1959 and then again in 1962. The story was taken up by the national press in 1964. Between September 1964 and August 1966 Godalming police station alone logged 362 reported sightings of the puma, although only forty-two were considered credible. Sightings continue to this day, as they do of other famous big cats, and therein lies the major weakness of those who argue that these beasts are real, for sightings last much longer than the natural lifespan of the animals. A few people explain this by saying that there must be breeding populations of each species living wild in the countryside, but it is hard to see how these would survive undetected, particularly in a densely populated county such as Surrey.

The Beast of Bodmin has become a part of British folklore, here featuring in the Dartmoor Border Morris celebrations on Bodmin Riding Day, 2011.

Many sceptics suggest that these sightings and paw prints are actually of large dogs, with people seeing them as cats because that is what they have been trained to do by popular expectation. Conversely, believers use the long tradition of sightings of spectral black dogs in Britain as evidence for earlier existence of felids. In Scotland the *Cu Sith*, 'fairy hounds', which are guardians of the fairy mounds, are known to leave large footprints, just as the alien big cats do. The most famous ghost hound is probably the fictional Hound of the Baskervilles, which Arthur Conan Doyle based on the well-established tradition that seeing such beasts presages a death. At least nine British families have traditions of black dogs that appear when a disaster is about to strike the family. More often the dogs are associated with a place, particularly lonely roads or graveyards, and are seen by terrified travellers at night (a fear purportedly used in the past by smugglers to keep people away from their activities).

Black dogs can also represent the Devil, carrying off souls to hell or wreaking havoc. The best-known of these is the Black Dog of Bungay, in Suffolk, which appeared in 1577. The dog is said to have rampaged through the church, where people were gathered to pray for deliverance from a terrible storm, killing and maiming several people, and at the same time the church tower was struck by lightning. As so often in Britain, modern locals have tamed what was once fearsome, and Bungay now has a black dog weathervane, and the dog appears on its coat of arms.

The Black Dog of Bungay, Suffolk, on the town weathervane.

Similar stories are found elsewhere. They are particularly common in East Anglia, where the dogs often go by the name of Black Shuck or Shock,

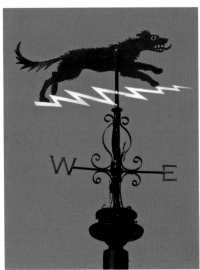

apparently from the Anglo-Saxon word *scucca*, 'devil'. In Lancashire and Yorkshire they can be called Skriker dogs, Padfoot around Leeds, and Hairy Jack in Lincolnshire, and Grim (again an old term for the Devil) in other places. They can also be known as Barghest, Guytrash, Hooter or Black Shag, while in Ireland they are Puka, the number of names reflecting how widely spread the legends are. Sometimes they appear to guard stiles or gates, preventing travellers from passing through, and in some places an attempt to scare them away by shouting at them means death to the shouter. Stories about these dogs can be traced back to the early Middle Ages and are still current today, both in real life and in fiction, a recent example being the appearance of the Grim in the Harry Potter novels.

But black dogs are not always malevolent. There is, for example, a Gaelic folktale of a dog, like

so many of its kin described as black, shaggy, and the size of a calf, with large red eyes, that took up residence with a dog lover and showed him where the lost family treasure was buried.

In Wales these dogs can be known as *Cwn Annwn*, 'the hounds of Annwn', the Celtic Otherworld. *Cwn Annwn* appear early in Welsh literature, being found in the medieval *Mabinogion*, where they are distinctive for their shining white bodies and red ears. But these *Cwn Annwn* are corporeal hounds, while in later folklore they are spectral. The term *Cwn Annwn* is also used of the hounds that hunt the souls of the dead through the air (in which case they can also be called *Cwn Cyrff*, 'corpse dogs', or *Cwn Wybr*, 'sky dogs'), and of the pack associated with the Wild Hunt. This pack, which hunts through the sky at certain times of the year and in stormy weather, and whose cry is associated with the calls of migrating geese, again goes by different names in different parts of the country. In Cornwall they are Dandy Dogs, after a priest carried off by the Devil when he hunted on a Sunday, and who is now doomed to hunt for evermore; in the North of England they are Gabriel Hounds or Rachets (an old word for a hunting dog), and elsewhere Yell or Yelth Hounds, or Wish Hounds. This Wild Hunt can be associated with King Arthur, or in modern folklore with Herne the Hunter, who seems to have been an invention of Shakespeare's and not a relic of pagan Celtic traditions, as is popularly supposed.

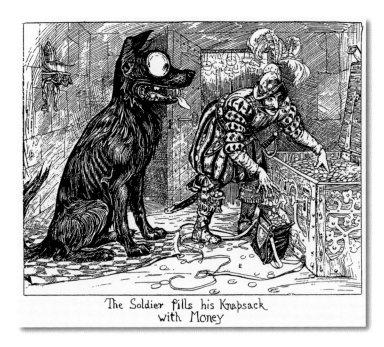

The Soldier Fills his Knapsack with Money

Black dogs with eyes as large as saucers, which can bring either good or bad luck, are well-known in northern European folklore: illustration by H. J. Ford for 'The Tinderbox' in Andrew Lang's *Yellow Fairy Book* (1894).

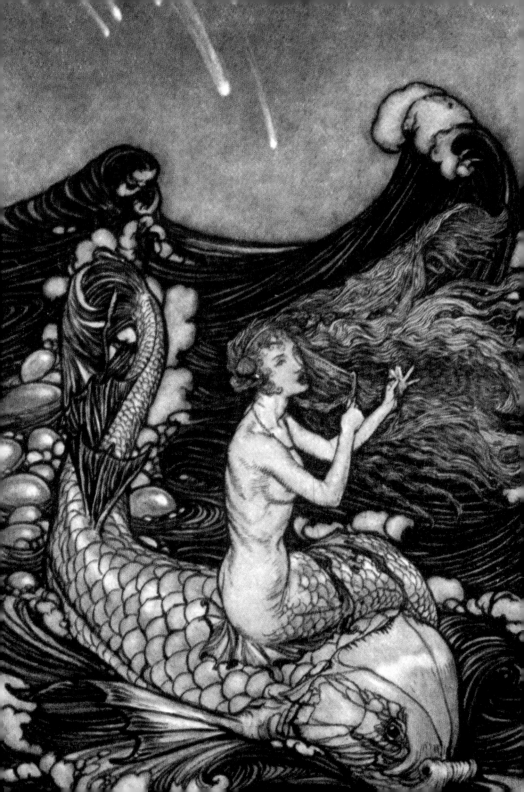

MERMAIDS, SELKIES AND FINN-FOLK

THE MODERN IDEA of the mermaid has been heavily influenced by Hans Christian Andersen's story of *The Little Mermaid*, and even more so by the softened, happy-ever-after Disney version of Andersen's grim original. Earlier mermaids were much more intimidating creatures. Although they could grant three wishes to someone who did them a good turn, their main function was to use their sexual wiles to lead humans to moral and physical destruction.

The origin of mermaids is rather muddled. 'Siren' is the word used in many languages for mermaids, yet the Greek sirens were half *bird*, half woman. But like mermaids they enticed passing sailors with their beautiful singing, so that the ships were wrecked on the rocky shores of the island on which the sirens lived. The Greeks also had the Nereids, humanoid sea nymphs, and Triton, a merman, who could blow on his conch to still or whip up the waves. In art we also find tritonesses, from whom we get our image of the mermaid, although the Greek ones often have split, double tails. These later became known in heraldry as Melusines, after the protagonist of a medieval romance. However, the siren/mermaid confusion remained, and hybrid bird-fish mermaids are sometimes found.

The association of mermaids with sexuality also goes back a long way. A fish-tailed fertility goddess had been worshipped in the Middle East and had some influence on Greek thought. The mirror and comb were a symbol of the goddess Aphrodite (the sexual symbolism enhanced by the fact that the Greek for 'comb' was also the term for 'vulva', and the fact that hair combing was essentially a bedroom occupation), and these passed from the goddess of love to the mermaid, who could now not only whip up a storm to drown a man, but could excite his lust and so destroy his soul. Thus she is shown in many church carvings as a dreadful warning against lust and vanity. Sometimes, to drive the point home, she has a fish, an early Christian symbol used here to represent the soul, clutched in her hands.

So low did the mermaid's reputation sink that in the sixteenth century she could be used as a symbol of prostitution, and when Mary, Queen of

Opposite: Arthur Rackham's 1908 depiction of Oberon's description of how he 'heard a mermaid on a dolphin's back/ Uttering such dulcet and harmonious breath/ That the rude sea grew civil at her song/And certain stars shot madly from their spheres/ To hear the seamaid's music' (*Midsummer Night's Dream* Act I Scene 2).

29

Right: Thirteenth-century male and female sirens from Exeter Cathedral, Devon. While they are clearly bird-bodied, there is a suggestion of the beginnings of fishy tails.

Centre left: Fifteenth-century twin-tailed mermaid misericord at Holy Trinity church, Stratford-upon-Avon.

Centre right: Half-way between a siren and a mermaid, this illumination holds a fish that represents the Christian soul trapped by her sinful wiles: English illumination, after 1236 (British Library, Harley 3244).

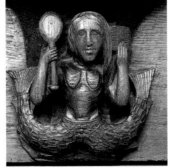

Right, inset: The double-tailed Melusine mermaid of the Starbucks logo is now a feature of many high streets.

Right: Modern replacement sculptures of the two tradtional forms of mermaid, single-tailed with mirror and comb, and double-tailed Melusine, on the south wall of Duke Humfrey's Library, Oxford.

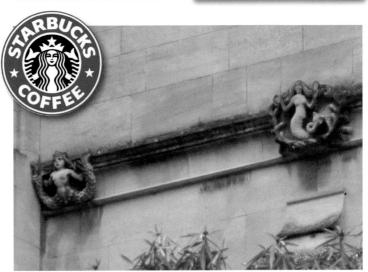

Scots was believed to have conspired with her probable lover (and third husband), Bothwell, in the murder of her then husband, Darnley, in 1567, placards appeared around Edinburgh depicting her as a mermaid.

The Renaissance was also the high point for serious accounts of mermaid sightings. There was a firm belief that the world was created in a way that meant that everything on the earth had its parallel in the sea, so it was quite reasonable to accept a race of aquatic humanoids. From the time of Columbus, explorers reported sightings of mermaids, now usually explained as wishful interpretations of manatees or seals.

This mermaid from Carlisle Cathedral has scales that look remarkably like feathers (compare the feathers on St Michael, page 15, from the same set of misericords). She holds a mirror in her left hand and would once have had a comb in her right.

The key attributes of mermaids – fish tails, long hair, singing, access to an undersea land and home where the riches of the deep are gathered, and sometimes a gift for prophecy of forthcoming danger – are all found in British merfolk, for in northern Europe mermen are as common as mermaids. There is particular emphasis on their love of music in many of the stories told about them. Cornwall, where they can be known as 'merrymaids', is rich in such stories. Best-known is that of the mermaid of Zennor, who is said to have come to church regularly, enticed by the beautiful voice of a chorister called Matthew Trewella. Eventually she in turn enticed him to live beneath the sea with her and, long after, his voice could be heard in Pendour Cove as he sang to her beneath the waves. In the church, the pew the mermaid used is marked by a fifteenth-century mermaid carving (see overleaf); in fact, the carving is probably the origin of the tale.

While stories about sea-folk are found all round the coast, they cluster most thickly in northern Scotland. The merfolk there have one distinctive

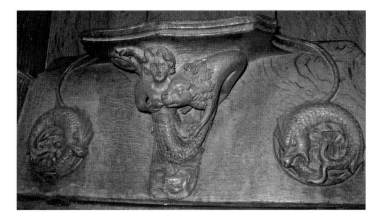

Misericords in four different churches show a mermaid suckling a lion. We have lost the story behind this scene, but, as mermaids represent the lusts of the flesh, we can be sure it signifies something bad: fifteenth-century misericord from Norwich, Norfolk.

It was thought by some that anything that existed on earth must exist in the sea, hence the 'sea bishop' and 'sea monk', illustrated in Caspar Schott's *Physica Curiosa* (1662).

feature: their fish tails are not permanent parts of their bodies; they wear them only for swimming, and they remove them in their aquatic halls and when they come to dance on land. (The 'merrows' of Ireland and the Isle of Man have no tails at all, but simply rather large feet, although they swim with the aid of little red caps, which give them their alternative name of Redcaps.) Because of this, the merfolk and land-dwellers have interbred. If a mermaid's fish skin is found and hidden, she cannot return to the sea and can be induced to marry a human. Sometimes it is a merman who doffs his tail and marries a land woman. Their descendants can be identified by scaly patches on their skin.

Similar tales of removable skins and marriage with humans are told of the seal-people, the selkies or selchies. At sea these may be indistinguishable from seals, which with their large eyes and habit of bobbing in the water with only their head and uppermost body showing can look remarkably human, but they too like to come ashore, remove their skins and dance. At least one bagpipe player is known to have been enticed to join them beneath the waves. Selkies should not be confused with the Finn-folk, who are humans who can shift their shapes by assuming seal skins, and who are usually wicked magicians.

While beings in lakes and rivers are sometimes described as mermaids, fresh water has its own distinctive hazards. The Anglo-Saxon epic *Beowulf* not only has the earliest English dragon but also introduces us to the monster Grendel and his mother. After Beowulf has killed Grendel, he has

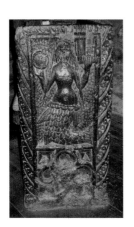

The fifteenth-century pew-end that lies behind the Cornish legend of the Zennor mermaid.

to track Grendel's vengeful mother down to her underwater lair, and when he enters the water the hideous hag reaches up and drags him under with her powerful arms. Grendel's name comes from 'to grind' and, from the place-name evidence, seems, like 'the bogeyman', to be both singular and plural at the same time, in that the monster is found in numerous places.

Grendel and his mother, both in name and behaviour, are the ancestors of the various Grindylows found throughout the country, which take particular pleasure in reaching up their long, green-skinned, skinny, but powerful, arms to drown children playing too near the

water, especially when they play on a Sunday. The best-known of these are Jenny Greenteeth, found particularly in Lancashire, and Peg Prowler, who haunts various parts of the River Tees. Her presence can be detected by froth ('Peg Prowler's Suds') or green scum ('Peg Prowler's cream'). Their male equivalent is called Rawhead-and-Bloody-Bones (alias Bloody Bones or Tommy Rawhead), who in modern folklore has moved to live under the sink or in the cupboard under the stairs.

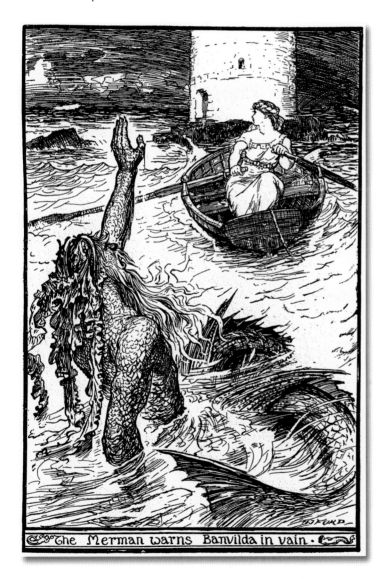

The Merman warns Banvilda in vain.

Northern European tradition is rich in mermen as well as mermaids. This illustration by H. J. Ford comes from Andrew Lang's *The Book of Romance* (1903).

NESSIE AND HER KIN

THE Loch Ness Monster is probably the most famous of the British mythical animals, but may also be the youngest. Great play has been made of a story in Adomnan's *Life of St Columba*. This biography, described by one authority as 'disappointing as a historical document', and written by a man who was not born until thirty years after Columba's death in 597, describes Columba saving a follower from a creature in the River (not Loch) Ness by making the sign of the cross – a typical early-medieval saint's miracle

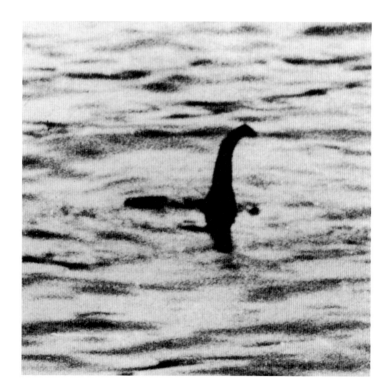

The definitive image of the Loch Ness Monster, known as the 'Surgeon's Photograph', first appeared in the *Daily Mail* on 21 April 1934. It was confirmed as a hoax in 1994.

that in no way resembles modern ideas about the monster. It is also claimed that there are Victorian references to a monster in the loch, but these stories are of a kelpie, of which more below, not a water-dwelling monster.

Nessie first appeared on the front page of the *Scottish Daily Record* in 1933, and in the *Daily Mail* later that year. Initially, this 'monster' was described in the same terms as the giant sea serpent, a creature that had attracted attention earlier in the year, but in 1934 a photograph in what is now the classic form of a plesiosaur appeared, again in the *Daily Mail*. It was not until 1994 that the perpetrators confessed that this was a fake, with the neck and body of a model dinosaur having been mounted on a toy submarine. Fakery has been present from the start – for example an early sighting of a footprint on the shore of Loch Ness turned out to have been made with a hippopotamus-foot umbrella stand, and it is remarkable how few definitive photographs have appeared since the 1950s and the introduction of clearer, colour photography.

In the 1980s Peter Maddocks turned the Loch Ness Monster into a much-loved children's animated cartoon, *The Family Ness*. This is the main character, Clever Ness, who shared the loch with others such as Lovely Ness, Eyewit Ness, Her High Ness and Grumpy Ness.

Apart from the way in which the photographs and descriptions of Nessie differ, there are practical difficulties for her existence. She (Nessie is an old Scottish pet form of Agnes, so she is always feminine) is often thought of as a left-over dinosaur from the Jurassic – but Loch Ness did not exist until after the last ice age, when the area was covered in a miles-deep layer of ice. She is treated as singular, but it is self-evident that there would need to be a breeding population, and attempts to conserve dwindling species show it would need to be large – so large that they would hardly have escaped detection.

What is extraordinary is how the idea of Nessie has grabbed the popular imagination. This may be because of other stories of water monsters, which are found worldwide, but particularly in Britain. There are monsters purportedly in Scotland's Loch Awe, Loch Rannoch and Loch Lomond, while 'Morag' purportedly haunts Loch Morar. Elsewhere, there is the Lake Champlain monster in the United States, and Sweden has one in Lake Storsjön (which, just in case, is covered by the country's wildlife protection laws), while in Africa we find Mokele-mbembe. A monster was spotted in Ireland's Loch Ree by three Catholic priests while out fishing in 1960. Whatever the cause, Nessie was rapidly tamed and turned into an object of affection.

There is still a British love for creating comic rather than frightening monsters. This 2011 graffito has since been removed.

The British Isles are also rich in stories of sea serpents and other creatures. The *Zoologist* in 1873 described a sighting of 'an animal, believed to be … the Norwegian Sea-serpent'

The idea of giant water monsters is old. Here a man pursues a *hydros* or water snake in a thirteenth-century illumination (British Library, Harley 3244).

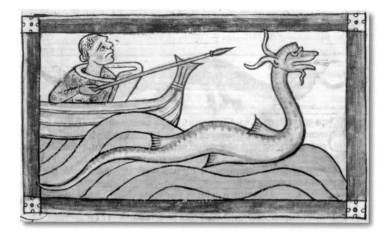

A sea serpent attacks a ship, taken from Olaus Magnus, *Historia de Gentibus Septentrionalibus* ('History of the Northern People') of 1555, reproduced in Charles Gould, *Mythical Monsters: Fact or Fiction* (1886).

off the Isle of Skye, which appeared in the form of a head, followed by a series of black lumps behind it, which 'gave the impression of a creature crooking up its back to sun itself', very reminiscent of Nessie in her serpent form. A remarkably similar description of a sea-serpent sighting was reported in 1965 from a little further south than the 1873 one. (Sceptics might suspect that something like a pod of whales may lie behind both sightings.)

Wales has its own water monsters, the Afanc or Avanc (occasionally Adanc). The name basically means 'water creature' and descriptions are vague and confusing, aggravated by the fact that *afanc* is the modern Welsh word for 'beaver'. The Afanc was said to live in various lakes, most famously Llyn Llion.

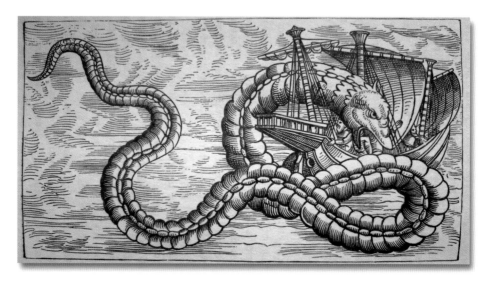

What looks very like an imaginative interpretation of a giant squid attacking a whale, reproduced in Charles Gould, *Mythical Monsters: Fact or Fiction* (1886).

Its perturbations of the lake could cause catastrophic flooding; it raided cattle and harmed anyone who swam in its waters. Accounts of how to catch it varied: some said it could be caught in the same way as a unicorn, by getting it to lay its head in a maiden's lap. In other stories it was fought and killed by heroes such as Peredur, King Arthur, or the folk hero Hu Gadarn (Hugh the Mighty), who dragged the Afanc out of Llyn Llion with his team of enormous oxen. Some describe the Afanc as having a horse-like head, which links it to the *Cefyl dwr* or water horse, the Welsh version of the better-known Scottish kelpie.

Detail of a Pictish standing stone (perhaps early-eighth-century) in the churchyard of Aberlemno, Angus. These water horses have been interpreted by some as kelpies.

Kelpies are shape-shifters that can appear in forms such as an old man, but are most frequently found as beautiful horses. They lurk by places such as deep fords, where travellers may be tempted to mount them to ride across in greater safety, but, once mounted, they gallop off to drown the rider in a deep pool or rapids. However, a person who knows the secret of a charmed halter may be able to catch the kelpie and force it to work for him. Kelpies are sometimes described as transforming into females, but these are more likely to be glaistigs, which are usually female creatures associated with caring for a house or farm, but are sometimes described as behaving like kelpies.

Shetland has its own kelpie-like creatures known as the Noggle, Nyugl, or similar spellings, and a variant known as the Nuckleavee, which tends to be more rugged and shaggy in form than the kelpie. England seems not to have these water horses, which belong in the rougher landscapes of the Celtic lands. In England, if a black horse carries someone off and attempts to drown him, it is more likely to be explained as the Devil in disguise.

3-metre-high maquettes of the kelpie statues created by Andie Scott. There are plans to build them full size by the end of 2013, when they will be 100 metres high and form part of the Forth & Clyde Canal lock system.

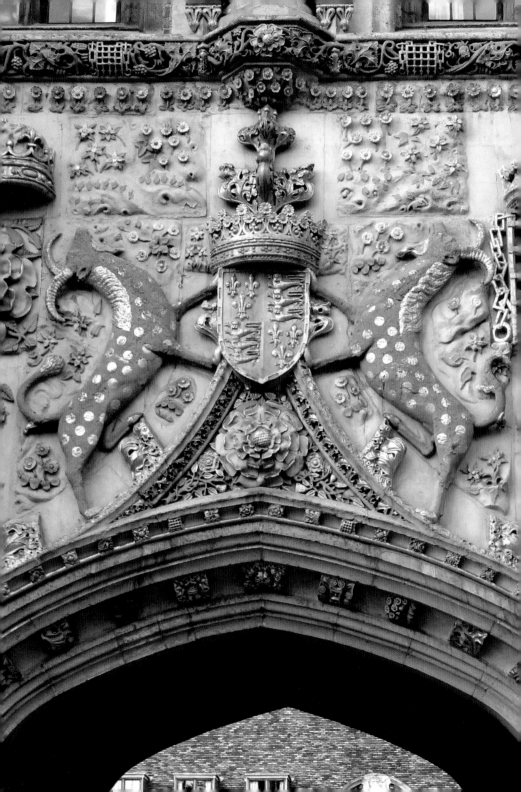

GRIFFINS,
UNICORNS AND YALES

WHEN Queen Elizabeth II was crowned in 1953, the entrance to Westminster Abbey was decorated with ten carved figures of the Royal Beasts: animals that had been used by her various ancestors as their heraldic symbols, and that she was therefore entitled to use as her own symbols. These beasts caused such a stir that a duplicate set was later commissioned from the sculptor, James Woodford, to adorn Kew Gardens (similar figures can also be seen at Hampton Court). Heraldic animals can be either real animals, such as the familiar lion of England, or mythical. They can be used in various ways and places: they may appear on the actual shield of the arms; as a crest above the coat of arms; or as a supporter (one of the figures flanking the shield). They could also be used as a family badge, or as an ornament handed out as brooches known as livery badges. Some badges are still familiar through pub signs: the White Hart, for example, was the personal symbol of Richard II, and the Bear and Ragged Staff that of the Earls of Warwick.

The most familiar of the heraldic mythical animals is the unicorn, which pairs up with the lion as a supporter of the royal coat of arms. This became one of the British royal beasts in 1603, when James VI of Scotland became James I of England and combined the arms of the two countries, joining the unicorn of Scotland with the English lion. In heraldry the unicorn is drawn with the body, head and mane of a horse, the tail of a lion, the beard of a goat and its own distinctive horn. The pictures in the medieval bestiaries are much more variable, showing the unicorn in a wide range of colours, shapes and sizes.

The symbolism of the unicorn was varied and mixed. While today we tend to see unicorns as pretty, magical and benign, originally it was the fiercest beast of the forest, so fierce that it would rather die than be captured, and this reputation for fierceness was probably one of the reasons it was chosen as an emblem. The only way to subdue a unicorn, as is well known, is to contrive an encounter between it and a virgin, in which case it will tamely lay its head in the virgin's lap. In modern times this appears to be an explicitly

Opposite:
The Beaufort yales supporting the royal coat of arms on the sixteenth-century gatehouse of St John's College, Cambridge, which was endowed by Margaret Beaufort, mother of Henry VII.

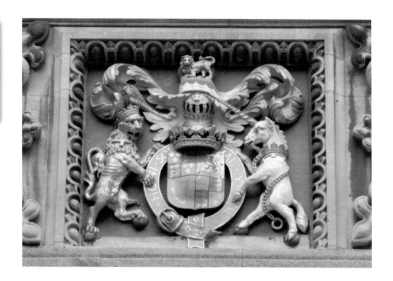

Above: White Hart pub sign, Modbury, Devon. Still one of the most popular pub names in Britain, this symbol goes back to the personal badge of Richard II (1367–1400).

Above right: Royal coat of arms on the Tower of the Five Orders, Bodleian Library, Oxford. The sculpture on the tower celebrates a visit in 1620 by James I of England (James VI of Scotland), who first combined the unicorn of Scotland with the lion of England in the British royal arms.

sexual image, but in the past surprisingly little was made of this, the image being interpreted rather as symbolic of the Virgin Mary and the incarnation of Christ.

From this, the unicorn became associated with purity. It was said that other animals let it go first to drink from a pool, for with its horn it could purge the water of all poisons and impurity. So strong was this connection with

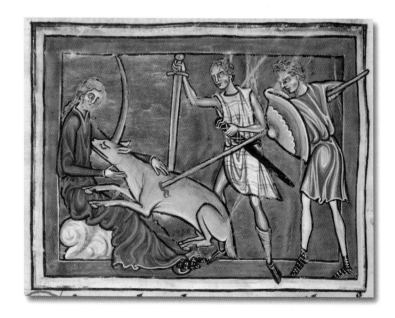

This English bestiary illumination of 1200–25 presents a very different image from the modern idea of a unicorn (British Library, Royal 12 C XIX).

purity that the unicorn became the commonest watermark for fifteenth-century European paper, indicating purity and whiteness, a colour it is still most strongly associated with. Its ability to remove toxins gave the horn the reputation as a cure-all, and any monarch worth his salt would own a unicorn horn (most often actually a narwhal's tusk), from which the lucky few could scrape a few medicinal shavings. This is why the unicorn is the supporter of the arms

of the Worshipful Society of Apothecaries, and why in a number of countries it can still be seen as a symbol of chemists' shops. Of all the classical mythical animals, the unicorn seemed to be the most likely to exist in reality, and explorers were seriously hoping to find its habitat well into the nineteenth century.

The griffin became one of the Queen's Beasts through her descent from Edward III, who used it as part of his personal device, where it is said to have represented strength and vigilance. The griffin (also known as a griffon or gryphon) has the body and tail of a lion, and the talons, wings, forequarters and head of an eagle, with the addition of distinctive tufted ears, although these do not always appear in the Middle Ages. The creature thus combined the features of the king of the beasts and the king of the birds. There are two similar animals in heraldry: the opinicus, which differs from the griffin only in having the tail of a camel, although it is sometimes shown without wings; and the male griffin, which occurs only in post-medieval heraldry, in what is known as the decadent period, and has no wings, but is surrounded by ray-like spikes. The griffin's attraction as a symbol for a knight was its reputation for fierceness. It was also known for its strength, and it was said that Alexander the Great had tried to fly to the heavens in a chariot harnessed to griffins, lured upwards by meat hanging above their heads, much as a donkey is said to be enticed by a carrot.

The griffin has a long history and there were a number of other traditions associated with it. It originated in ancient Mesopotamia. By the time it reached Minoan Crete, it seems to have been associated with the gods, and to have acted as an intermediary between the lands of the living and the dead, an association it retained throughout classical times. For the Mycenaean Greeks it was a symbol of kingship. At least as early as the fifth century BC, stories were circulating about the gold-rich lands that the griffins fiercely defended from the one-eyed

Unicorn hunt misericord from Chester Cathedral, Cheshire, 1390. Two wyverns look on.

A seventeenth-century image of a unicorn from Edward Topsell, *The History of Four-Footed Beasts and Serpents* (1658).

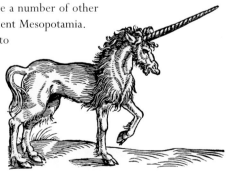

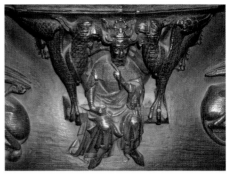

Above:
Griffin misericord,
Chester Cathedral,
Cheshire, 1390.

Above right:
A popular
medieval story was
of Alexander the
Great's attempt
to scale the
heavens in a
chariot powered
by griffins. It is the
subject of several
misericords. This
one, in Chester
Cathedral,
Cheshire, dates
from 1390.

Below left:
The Midland
Bank griffins in
their various
manifestations.

Far right:
The coat of
arms of the
Midland Bank,
demonstrating
how easily heraldic
dragons and
griffins can be
confused.

Arimaspians, who tried to steal their gold. From this the griffin gained a reputation as a guardian of treasure, and so it was adopted as a symbol by a number of banks, most notably in Britain by the Midland Bank, which disappeared from the High Street in 1999. Through various redesigns, the bank's logo remained a rampant griffin, surrounded by golden disks, known technically in heraldry as bezants, the name of an obsolete coin. The griffin also appears as a supporter in the arms of the company, with a dragon, or more accurately a wyvern, appearing as the other supporter. The illustration shows how easily heraldic dragons and griffins can be confused.

Still current is the much redesigned heraldic griffin of Vauxhall cars. This too has a long history. In the thirteenth century King John hired a mercenary called Falkes de Bréauté. Rewarded for his service with the right to bear arms, he chose the fierce, warlike griffin as his symbol. He also acquired land on the south bank of the River Thames not far from London. The house he built there was known as Fulk's Hall, which eventually became 'Vauxhall'. Vauxhall Iron Works, founded in the nineteenth century, later evolved into Vauxhall Motors and adopted Falkes's griffin as its logo.

Unicorn, griffin and dragon are the most popular heraldic animals and still the most likely to be seen. Less well-known is the final mythical animal among the Queen's Beasts, the yale. This creature was first adopted into the royal family by John, Duke of Bedford (1389–1435), brother of Henry V, and regent of France for his infant nephew Henry VI. When the dukedom passed into the Beaufort family, the yale went with it, and Margaret Beaufort, the influential

1952

1965

1988

mother of Henry VII, used two yales as the supporters of her arms. The Bedford and Beaufort yales differed considerably in appearance, as indeed do pictures of the animal in bestiaries. Bedford's yale has a deer-like body, a lion's tail and a boar's snout, while the Beaufort yale is goat-like. What they do share is the distinctive boar's tushes (tusks), and the great horns, pointing in different directions. The yale does not have the rich back-story of the unicorn and griffin, although it is equally aggressive. It has one distinctive feature: fierce horns that it can move at will independently of each other, so that they can swivel round to meet attack from any direction. While Bedford's yale was a naturalistic brown, Margaret Beaufort's yales were colourful beasts, with a white body covered in gold bezants or spots, and gold hooves, horns, tushes and tufts. They can be seen on the gateways of two Cambridge colleges: St John's College, which she founded, and Christ's, to which she gave endowments.

A modern griffin: the Vauxhall car badge.

There are other, less usual mythical creatures found in heraldry. These include the cockatrice or basilisk, a creature described in the bestiaries as hatched from a rooster's egg by a toad, with a serpent's head and tail and the feet and wings of a cockerel. In Christian art it became a symbol of the

A yale from an English bestiary of 1200–25 (British Library, Royal 12 C XIX).

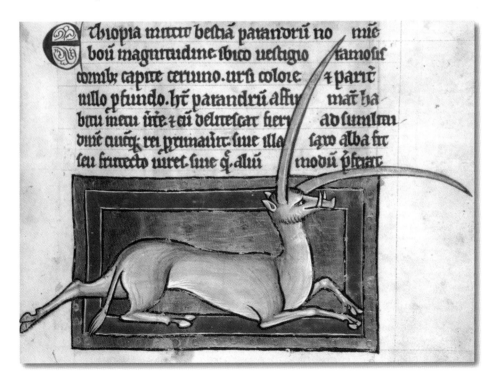

Right: Fifteenth-century cockatrice misericord from Great Malvern Priory, Worcestershire.

Far right: The cockatrice of Wherwell Abbey commemorated in a mosaic in the High Street at Andover, Hampshire.

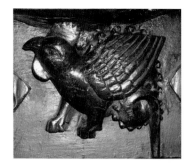

Antichrist. Its most distinctive feature was its ability to kill with its look. British folklore features a number of cunning heroes who kill cockatrices by tricking them into seeing their own reflections, such as the one at Wherwell Abbey, Hampshire, still celebrated in nearby Andover. A cockatrice is said to have emerged from the crypt of Renwick church, Cumbria, during renovations as recently as 1733. In heraldry the cockatrice is shown as a wyvern with a cockerel's head.

Another reptilian creature is the salamander, a lizard- or snake-like creature of such cold that it could live in fire and even put out the flames. This ability meant that it was compared with the survival of the biblical Shadrach, Meshach and Abednego, who survived the fiery furnace (Daniel 1–3), and so came to represent the righteous and those who put their faith in God. Its association with fire was also significant in alchemy.

There are occasional appearances in heraldry of other creatures from classical myth, such as the winged horse Pegasus, the phoenix, which rises from

Miniature of a cockatrice from an early-thirteenth-century English bestiary. A man has been killed by its gaze. The only animal that is unaffected by it, and so can kill it, is the weasel, shown here on the left (British Library, Royal 12 C XIX).

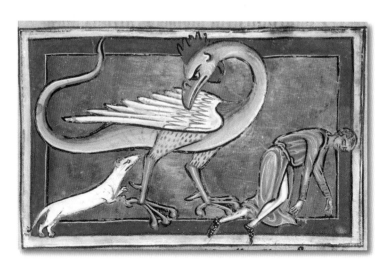

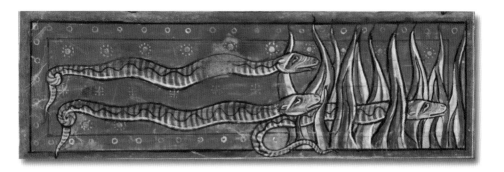

its own ashes and symbolises rebirth, and centaurs. But later heraldry also created its own composite animals, chopping and changing different parts at will, or adding such features as wings. Most notably, they created sea creatures by putting a fish's lower part on the top half of a land animal. In classical art we already find the sea horse – half horse, half fish – and occasionally the sea griffin, but now we find such exotica as literal sea lions, sea dogs, sea stags and sea wyverns (see title page image).

Salamanders heading for the fire: miniature from an English bestiary, 1225–50 (British Library, Harley 4751).

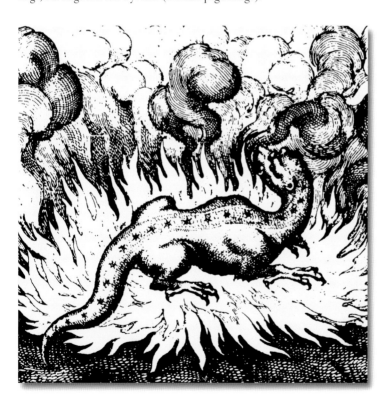

Salamanders were important in alchemy: illustration from Michaelis Majeri, *Secretorum Chymicum* (1689).

45

FURTHER READING

GENERAL

Alexander, Mark. *A Companion to the Folklore, Myth and Customs of Britain*.
Sutton Publishing, 2002.

Jones, T. Gwynn. *Welsh Folklore and Folk-Custom*. D. S. Brewer, 1979
(first published 1930).

Pratchett, Terry, and Simpson, Jacqueline. *The Folklore of the Discworld: Legends,
Myths and Customs from the Discworld with Helpful Hints from Planet Earth*.
Corgi, 2009.

Westwood, Jennifer, and Kingshill, Sophia. *The Lore of Scotland: A Guide to
Scottish Legends*. Random House, 2009.

Westwood, Jennifer, and Simpson, Jacqueline. *The Lore of the Land: A Guide
to England's Legends*, Penguin Books, 2005.

The Medieval Bestiary: www.bestiary.ca

Misericords of the World: www.misericords.co.uk

DRAGONS

Simpson, Jacqueline. 'Fifty British Dragon Tales: An Analysis', *Folklore*, 89, 1
(1978), pp. 79–93.

Simpson, Jacqueline. *British Dragons*. Wordsworth Editions, in association
with the Folklore Society, second edition 2001.

CATS AND DOGS

Bromwich, Rachel (editor and translator). *Trioedd Ynys Prydein: The Welsh Triads*.
University of Wales Press, third edition, 2006.

Bromwich, Rachel, et al (editors). *The Arthur of the Welsh*. University
of Wales Press, 1991.

Buller, Henry. 'Where the Wild Things Are: The Evolving Iconography
of Rural Fauna', *Journal of Rural Studies*, 20 (2004), pp. 131–141.

Goss, Michael. 'Big Cat Sightings in Britain: A Possible Rumour Legend?',
Folklore, 103, 2 (1992), pp. 184–202.

Nic Leodhas, Sorche. *Gaelic Ghosts, Tales of the Supernatural from Scotland*.
Bodley Head, 1966.

Nutt, Alfred. 'Celtic Myth and Saga. Report upon the Progress of Study
during the Past Eighteen Months', *Folklore* 1, 2 (June 1890),
pp. 234–260.

MERMAIDS

Chambers, R. W., and Wrenn, C. L. *Beowulf: An Introduction to the Study
of the Poem with a Discussion of the Stories of Offa and Finn*. Oxford
University Press, third edition 1967 (first published 1921).

Teit, J. A. 'Water-Beings in Shetlandic Folk-Lore', *Journal of American Folk Lore*, 31, 120.

LOCH NESS MONSTER

Bauer, Henry H. 'The Case for the Loch Ness "Monster": The Scientific Evidence', *Journal of Scientific Exploration*, 16, 2.
www.Loch-ness.org

HERALDRY

Friar, Stephen. *The Companion to Heraldry*. History Press, 2004 (first published 1992).

THE YALE

www.web.archive.org/web/20060117152854/http://gateway. kwantlen.bc.ca/~donna/sca/yale/

INDEX

Page numbers in italics refer to illustrations

Afanc, Avanc, Adanc 36–7
Alien big cats 23–6
Aphrodite 29
Arthur, King 10, 16, 21, 23, 27, 37
Ashipattle 19
Bamburgh Castle 18
Barghest 26
Basilisk 43–4, *44*
Beast of Bodmin 25, *25*
Beast of Exmoor 25
Beaufort, Margaret 42–3
Bedford, John Duke of 42–3
Beowulf 11, 32
Bestiaries 6, 39
Bishop Auckland 19
Black dogs 26–7
Black Shuck, Shock or Shag 26
British attitudes to legends 5
British heroes 5
Bungay 26
Cadbury Castle 16
Cadwaladr, King 10
Cait sith 23–4
Cambridgeshire Tiger 25
Carantoc, St 16
Cath Balug, Cath Palug 21–3, *23*
Cats 21–6, *22*; folk cures and cats
 21; Irish 23; King of the Cats 21,
 wild cats 23–4, *24*
Chapalu 22
Childe Wynd 18
Coat of Arms *1*, *38*, 39–44, *42*
Cockatrice 43–4, *44*
Colomba, St 34
Colombus, Christopher 31
Conyers, Sir John 19
Cu sith 26
Cwn Annwn, Cwn Cyrff, Cwn Wybr 27
Dandy dogs 27
Deerhurst Dragon 6, *6*
Devil, the 14, 26–7
Dogs 26–7
Dolbury Hill 16
Draco Roman standard 10, *11*

Dragons *3*, 6, *8*, 9–20, *14*, *18*; in
 the Bible 9; origin of word 9;
 Roman 9–10; Saxon 11; Welsh
 10, *11*, 16, 19–20; Wessex 11
Dragon Hill 15–16, *17*
Draig 12
Drake 11
Eden, Garden of 14
Falchion 19, 20
Family Ness *35*
Felicity the Cannich puma 24–5, *24*
Finn folk 32
Gabriel Hounds 27
George, St 14–16,
Glaistigs 37
Grendel 32
Griffins 41–3, *42–3*
Grim 26
Grindylows 32–3
Guytrash 26
Gwyber 13
Hairy Jack 26
Herne the Hunter 27
Hooter 26
Hound of the Baskervilles 26
Hu Gadarn 37
Hybrid animals 7, 45
International popular tale 5
James I and VI, King 39
Jenny Greenteeth 33
Kay, Sir 21, 23
Kellas cats 24
Kelpies 35, 37, *37*
Knucker Hole, Lyminster 17
Laidly Worm 17–18
Lambton Worm 18–19
Loch Ness Monster 34–5, *34*,
Lynx 23–4, *24*
Mary, Queen of Scots 29–30
Melusine 29, *30*
Mermaids *28*, 29–32, *30–3*
Merrows 32
Merrymaids 31
Michael, Saint 14, *14*, 15, 16, *17*
Milk as dragon food 6,
Misericords 6–7, *7*
More of More Hall 18
Murchata 23
Nathair–sgiathach 12

Noggle 37
Nuckleavee 37
Orkney 19–20
Orme 11
Padfoot 26
Palug's Cat 21–3, *23*
Peg Prowler 33
Pendragon 10
Peredur 37
Pollard of Pollard Hall 19
Pub names *16*, 39, *40*
Puka 26
Puma 23, *24*, 25
Rawhead-and-Bloody-Bones 33
Redcaps 32
Royal Beasts 39–40
Salamander 44, *45*
Samson, St 16
Sea bishop, sea monk *32*
Sea horse *1*, 45
Selkies, selchies 32
Serpents *8*, *13*, 14, 35–6, *36*
Sheppey Panther 25
Sirens 29, *30*
Skriker dogs 26
Snakes 9, 11–12, 14, *36*
Sockburn 19
Sources 5, 7
Stoor Worm 19
Surrey Puma 25
Sutton Hoo 11, *12*
Tolkien, J. R. R. 11
Tom Tildrum 21
Triton 29
Uffington White Horse 15, *17*
Unicorns 37, 39–41, *40–1*
Vauxhall 42
Wantley Dragon 18, *19*
Whittington, Dick 21, *22*
Wild Hunt 27
Wish hounds 27
Worm, wyrme 11
Wormelow 16
Wormwood Scrubs 11
Wyvern 12–13, *41*
Yales *38*, 42–3, *43*
Yell or Yelth hounds 27
Zennor 31